Where cats meditate

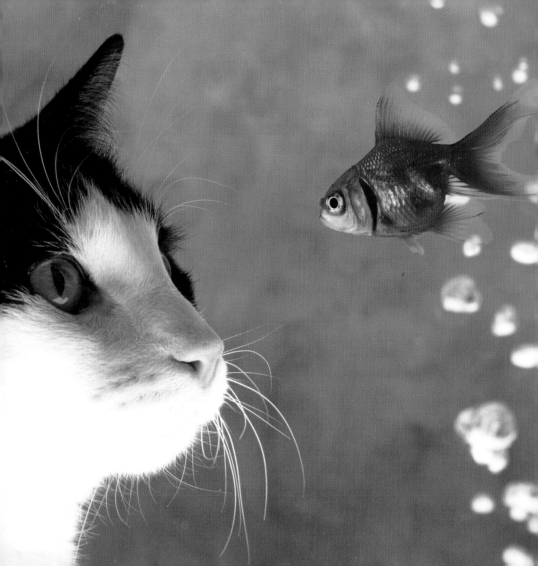

Where cats meditate

Edited by David Baird

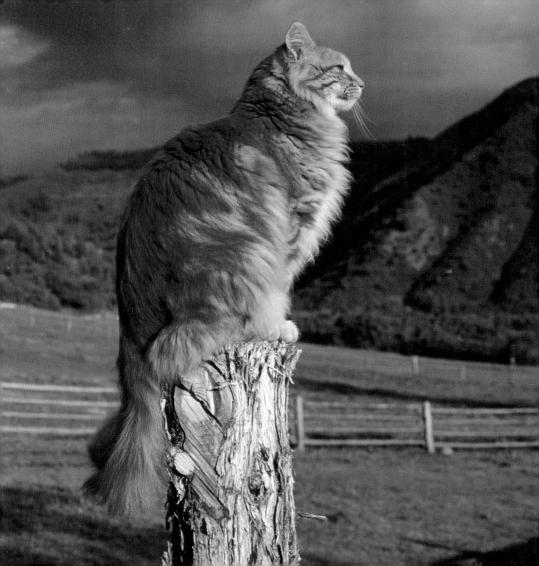

To be able to listen to the silence is to be able to hear the infinite.

Anne Wilson Schaef

today
I shall rake leaves
or perhaps follow
that red maple leaf
down stream...

or not

Evelyn Lang

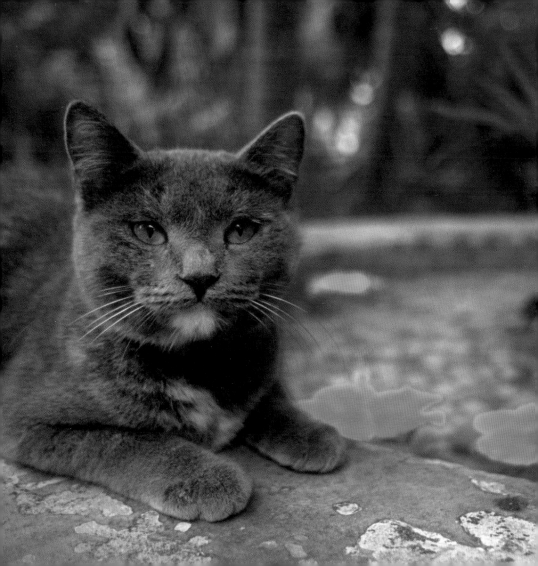

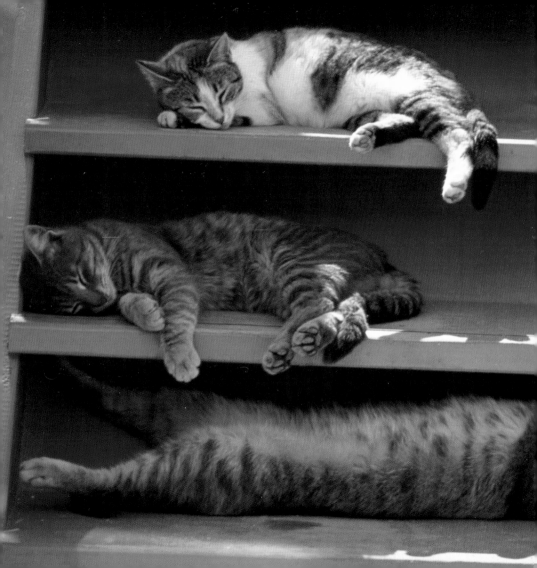

I sleep...I wake...
How wide
The bed with none beside.

Kaga no Chiyo
translated by Curtis Hidden Page

Nothing can bring you peace but yourself.

Ralph Waldo Emerson

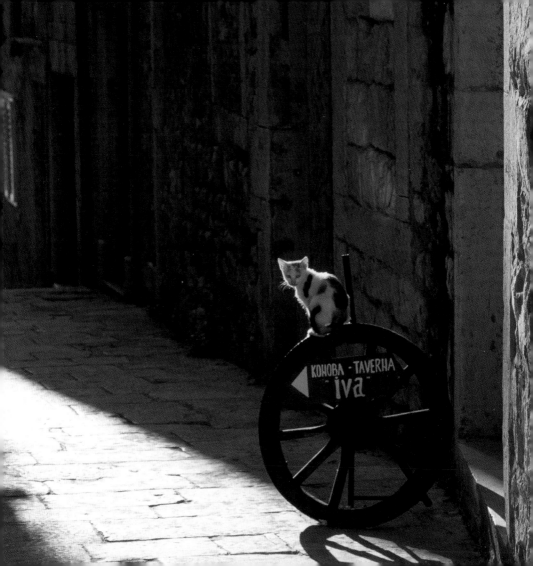

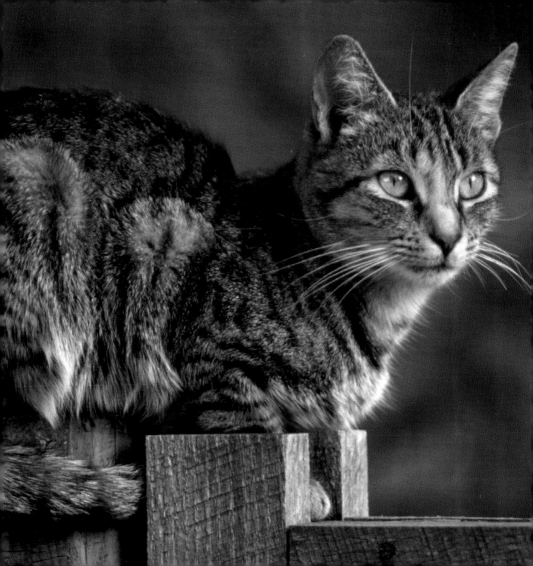

Those in a hurry do not arrive.

Zen saying

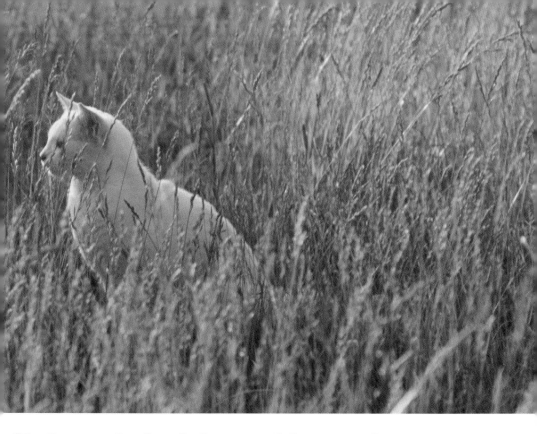

Sitting quietly, doing nothing, spring comes, and the grass grows by itself.

Zen saying

The greatest prayer is patience.

Buddha

the waves sound sometimes
close and sometimes far away
how much more of life

Santoka
translated by Cid Corman

As an eagle, weary after soaring in the sky, folds its wings and flies down to rest in its nest, so does the shining Self enter the state of dreamless sleep, where one is freed from all desires.

Brihadaranyaka Upanishad

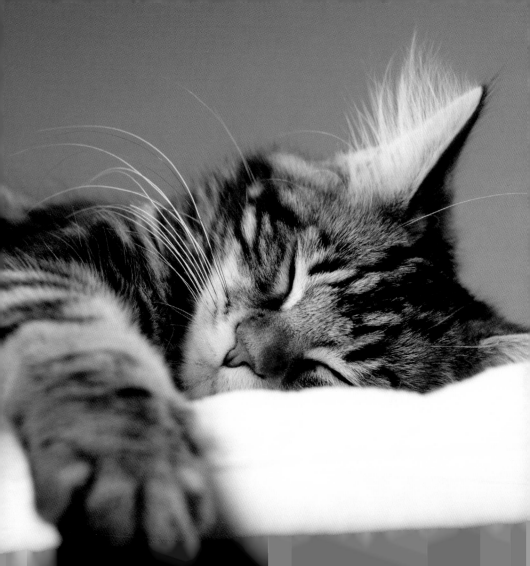

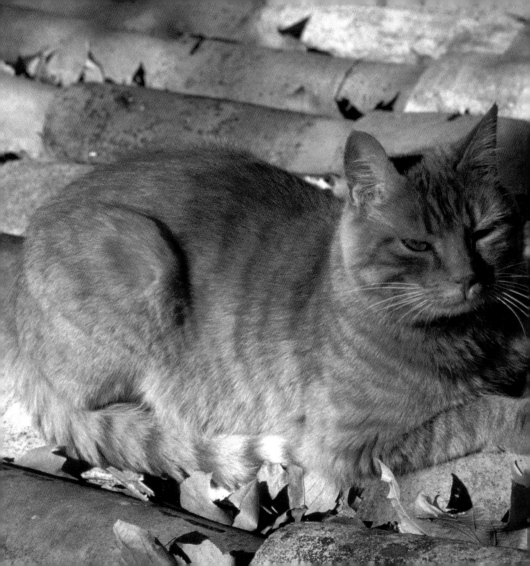

I hear the wind a-blowing,
I hear the corn a-growing,
I hear the Virgin praying,
I hear what she is saying!

Hester Sigerson

There is no place
to seek the mind;
It is like the footprints
of birds in the sky.

Zenrin

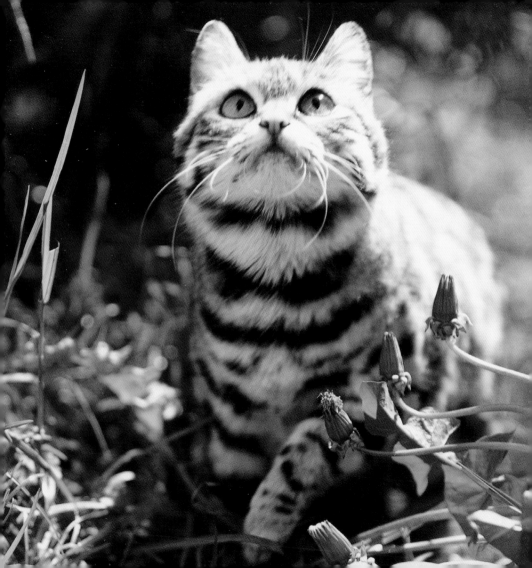

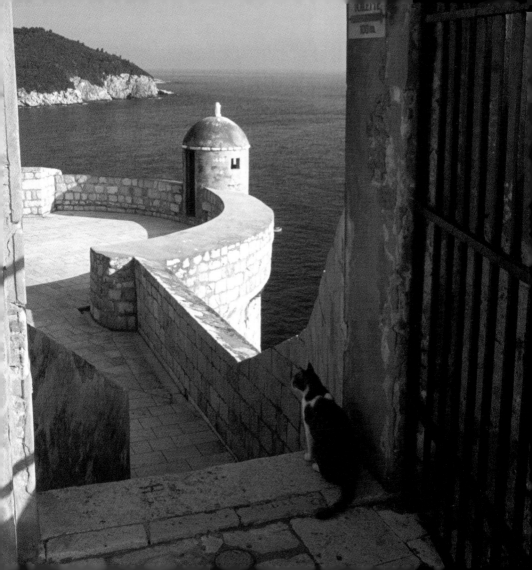

The real voyage of discovery consists not in seeking new landscapes, but in having new eyes.

Marcel Proust

The quieter you become, the more you can hear.

Baba Ram Dass

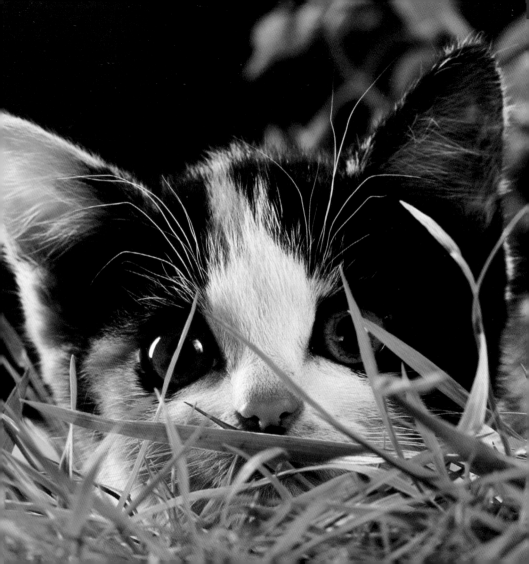

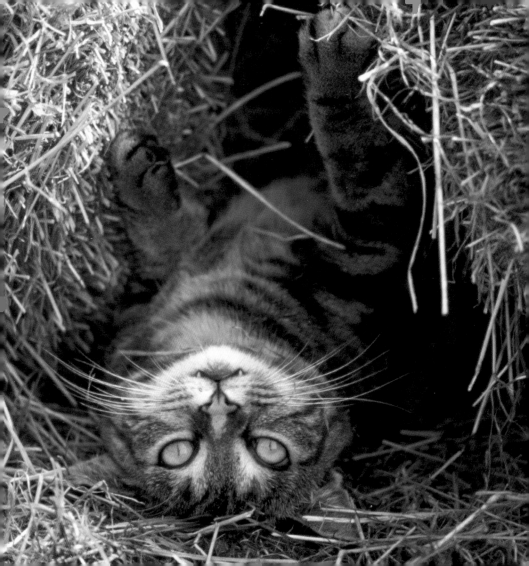

When all is done and said, in the end
 thus shall you find,
He most of all doth bathe in bliss that
 hath a quiet mind;
And, clear from worldly cares, to deem
 can be content
The sweetest time in all his life in
 thinking to be spent.

Lord Thomas Vaux

The bird of paradise alights only upon the hand that does not grasp.

John Berry

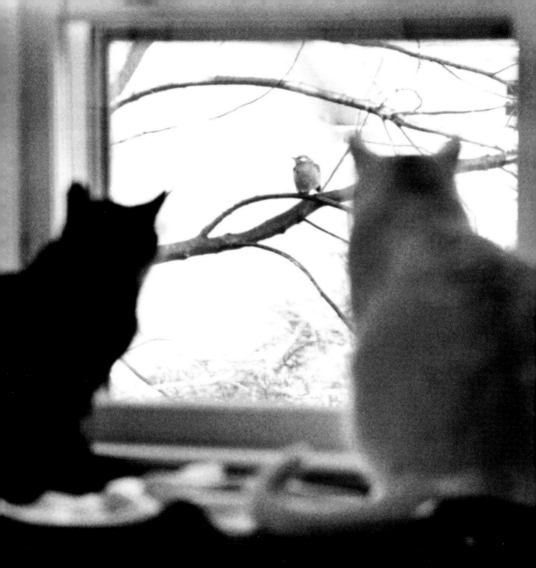

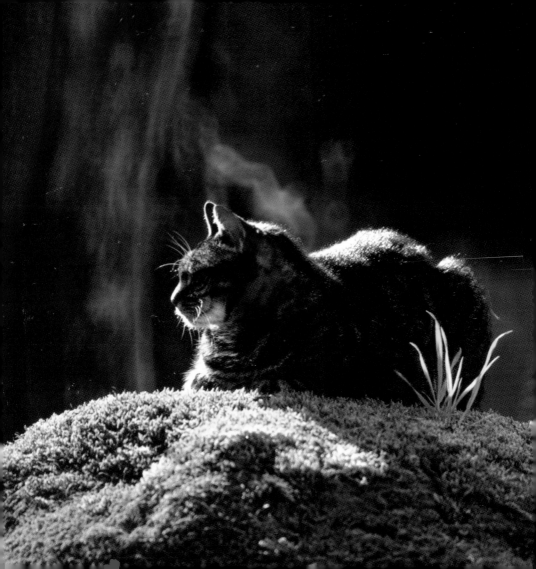

We must learn to be still in the midst of activity and to be vibrantly alive in repose.

Indira Gandhi

He who hunts for flowers will find flowers;
and he who loves weeds will find weeds.

Henry Ward Beecher

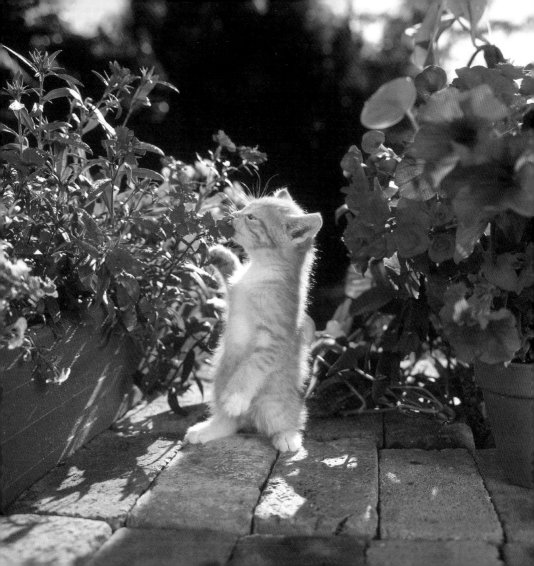

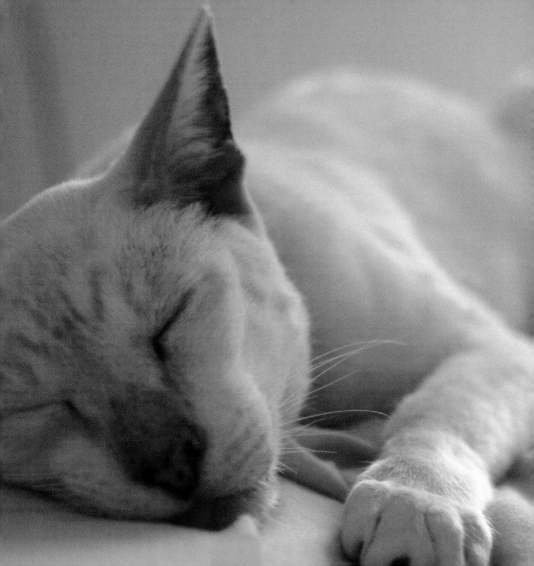

Letting the world be: I'm a monk, having an Afternoon nap.

Natsume Soseki
translated by Soiku Shigematsu

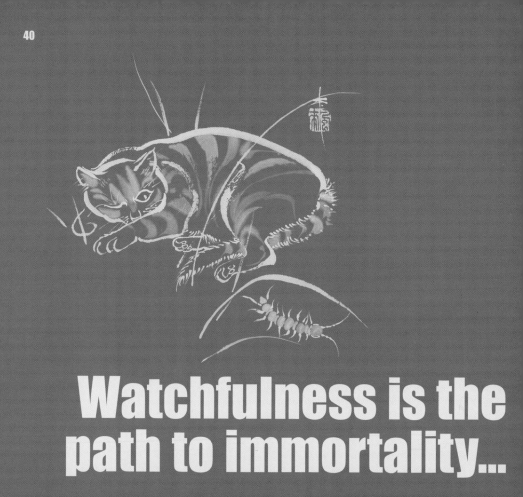

Watchfulness is the path to immortality...

Dhammapada

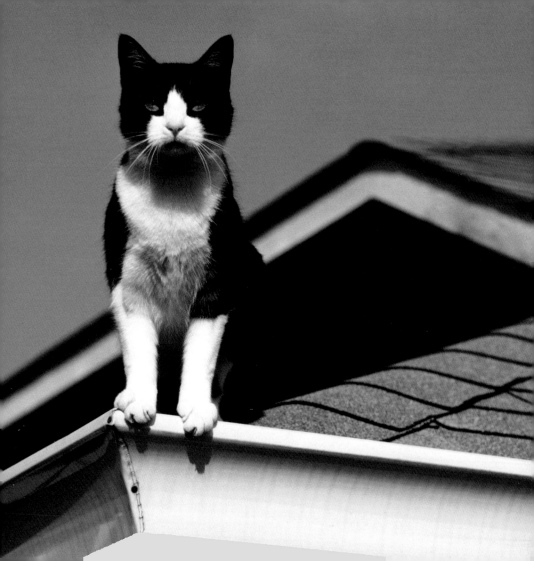

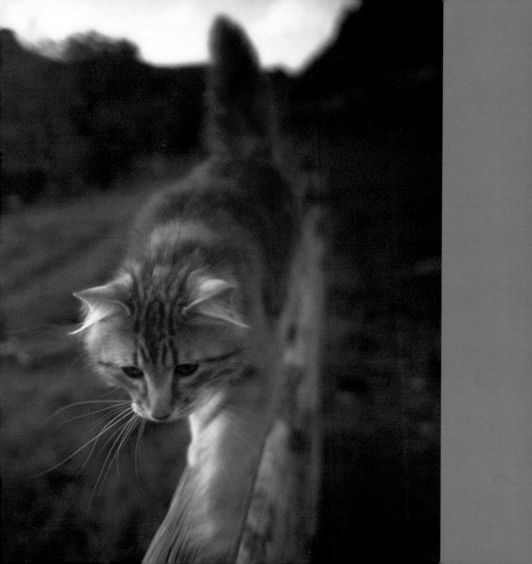

I neither follow the Way nor depart from it. I neither worship the Buddha nor have contempt for him. I neither sit long hours in meditation nor sit idle. I neither eat just one meal a day nor am I greedy for more. I desire nothing, and that is what I call the Way.

Vasubandhu

Be vigilant; guard your mind against negative thoughts.

Buddha

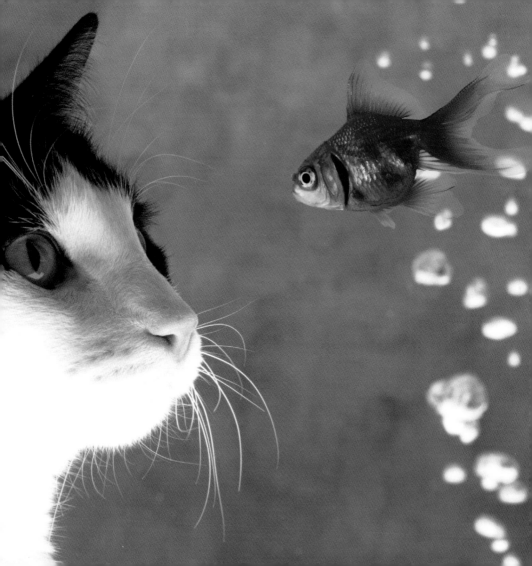

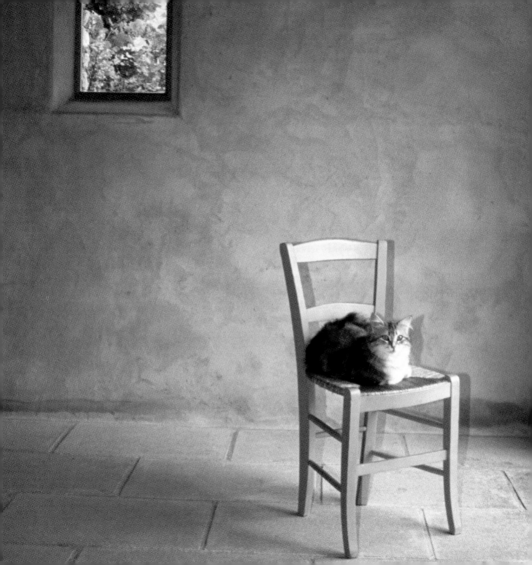

While walking, examine the walking; while sitting, the sitting...

Zen saying

To see a world in a grain of sand
And a heaven in a wild flower,
Hold infinity in the palm of your hand
And eternity in an hour.

William Blake

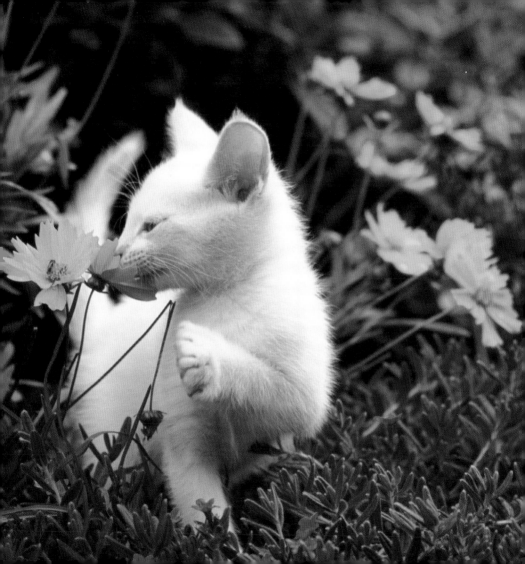

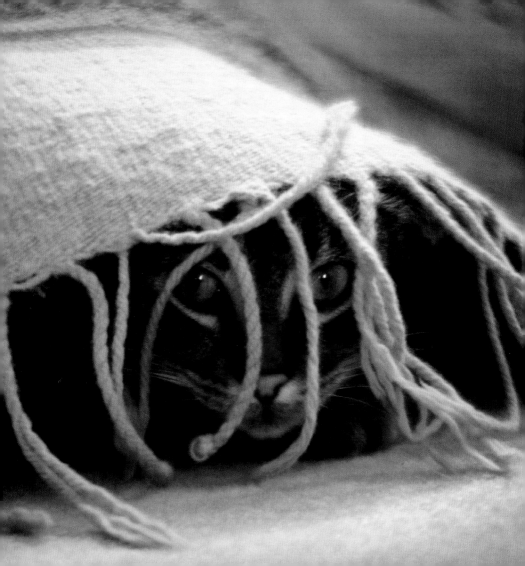

Vision is the art of seeing things invisible.

Jonathan Swift

Friends are the sunshine of life.

John Hay

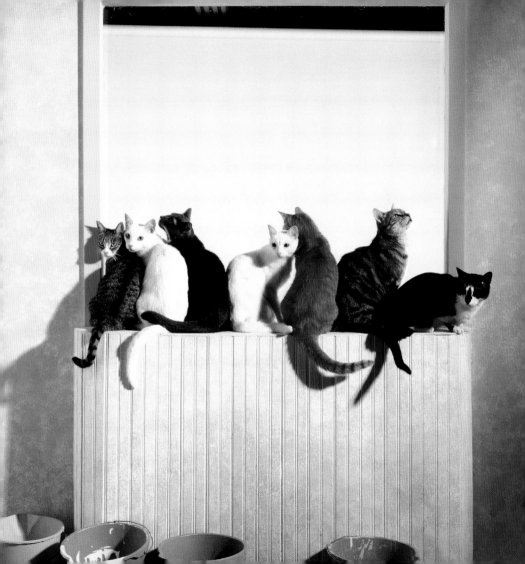

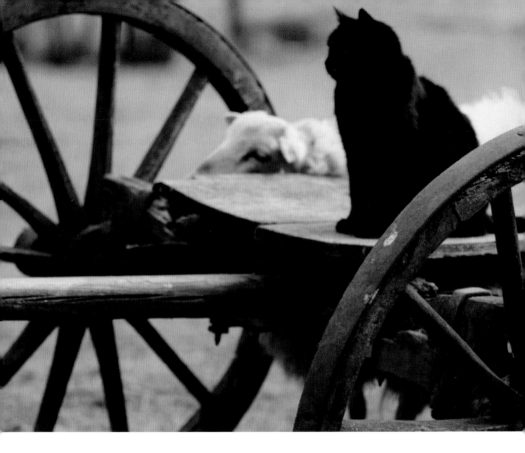

Yes, there is a Nirvana; it is in leading your sheep to a green pasture, and in putting your child to

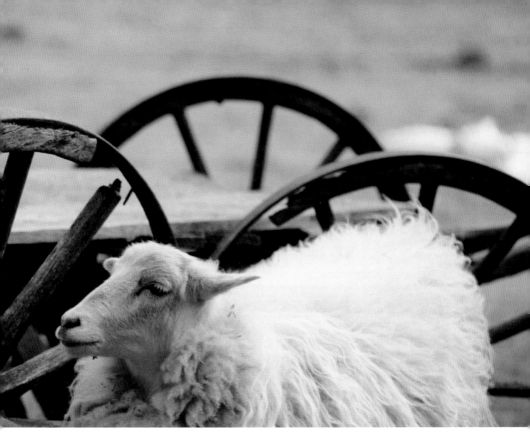

sleep, and in writing the last line of your poem.

Kahlil Gibran

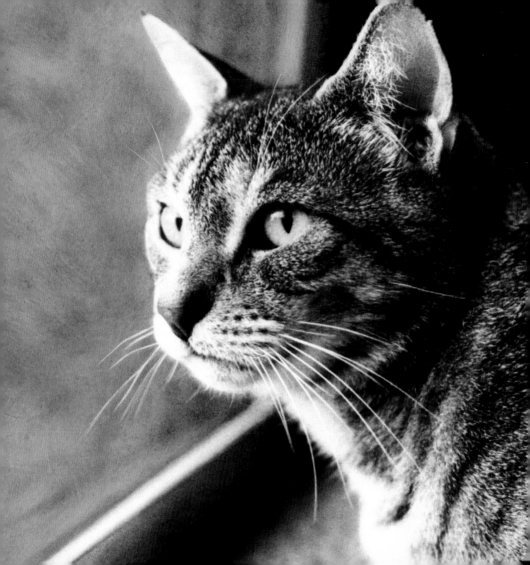

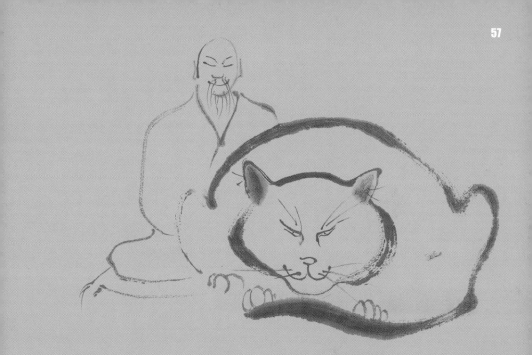

The eye with which I see God is the same eye with which God sees me.

Meister Eckhart

Nature has given us two ears, two eyes, and but one tongue—to the end that we should hear and see more than we speak.

Socrates

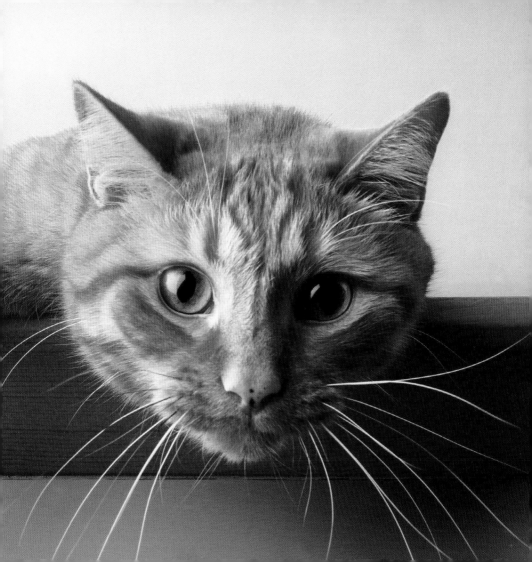

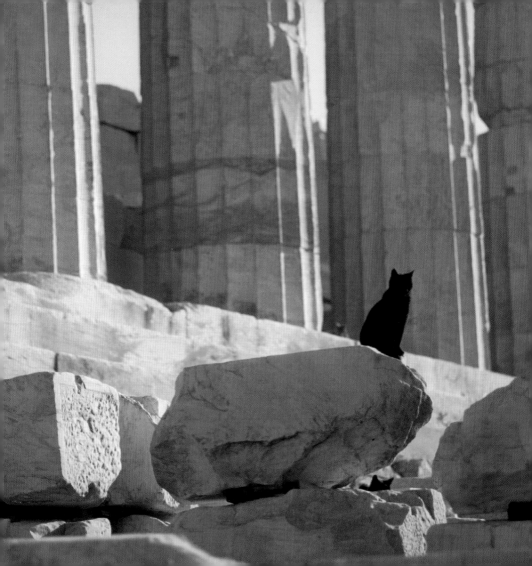

I've left the world behind:
Even the busy streets
An ancient scene.

Natsume Soseki
translated by Soiku Shigematsu

He can't think without his hat.

Samuel Beckett

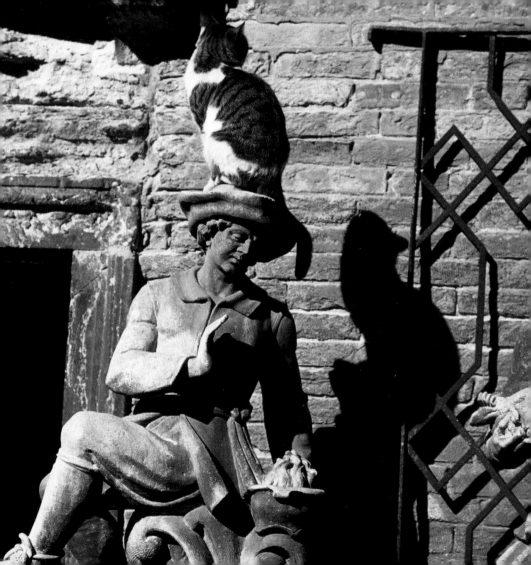

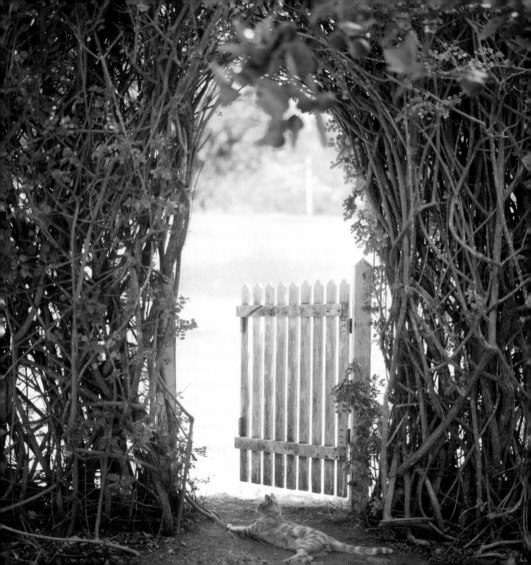

The moon
has cleared a path through the wood
And guided the stream
right to my gate.

David Baird

Keep your face to the sunshine and you cannot see the shadow.

Helen Keller

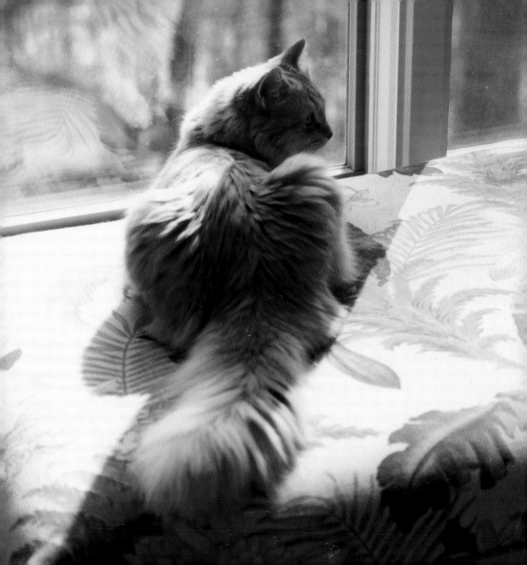

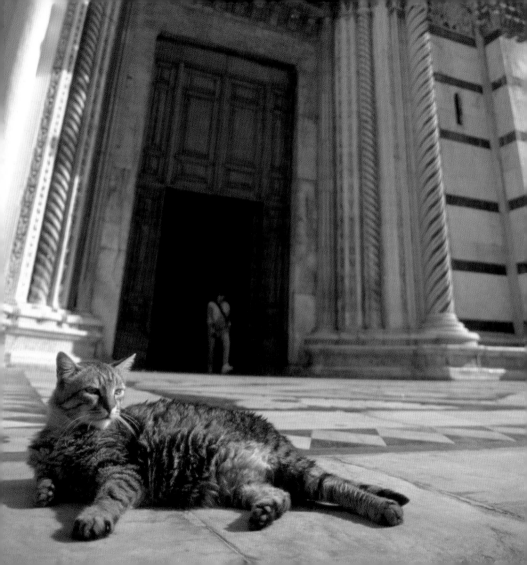

**A peace above all earthly dignities,
A still and quiet conscience.**

William Shakespeare

Every blade of grass has its angel that bends over it and whispers, "grow, grow."

The Talmud

A tree that can fill the span of a man's arms
grows from a downy tip;
A terrace nine stories high
rises from hodfuls of earth;
A journey of a thousand miles
starts from beneath one's feet.

Lao-Tzu

To sit in the shade on a fine day, and look upon verdure is the most perfect refreshment.

Jane Austen

Without stirring abroad,
One can know the whole world;
Without looking out of the window,
One can see the way of heaven.
The further one goes
The less one knows.

Lao-Tzu

Pebbles on the riverbed
Wavering:
Clear water.

Natsume Soseki

translated by Soiku Shigematsu

Three stone steps lead
to where a granite outcrop
shelters a scrap of ledge,
the place I go to study
the shadow dust...

Chase Twichell

Put all your eggs in the one basket and watch that basket.

Mark Twain

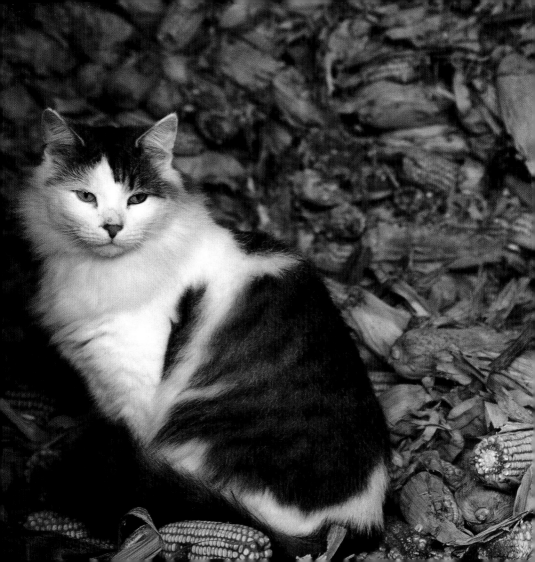

The wind and the corn talk things over together.
And the rain and the corn and the sun and the corn
Talk things over together.

Carl Sandburg

One is not idle because one is absorbed. There is both visible and invisible labor. To contemplate is to toil, to think is to do. The crossed arms work, the clasped hands act. The eyes upturned to Heaven are an act of creation.

Victor Hugo

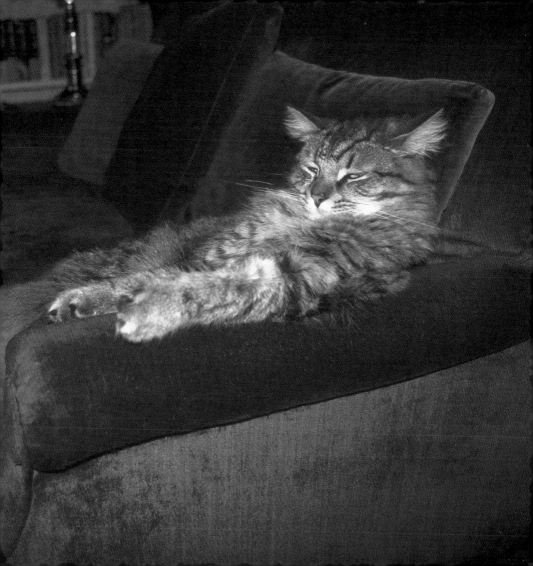

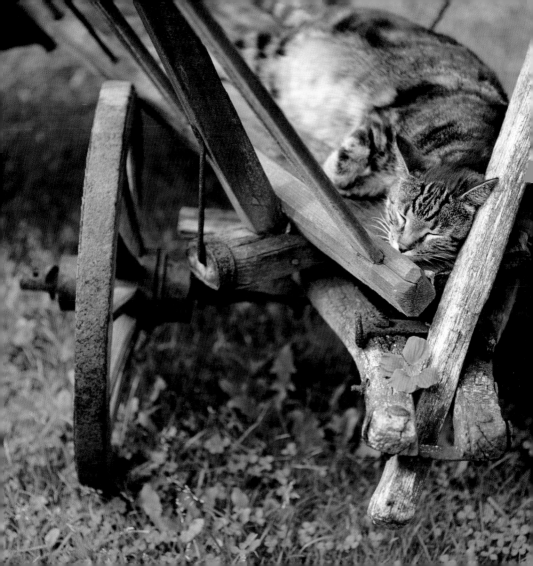

Rest is not idleness,
and to lie sometimes on the grass
under trees on a summer's day,
listening to the murmur of the water, or
watching the clouds float across the
sky, is by no means a waste of time.

Sir John Lubbock

When you come to the end of a perfect day,
And you sit alone with your thought,
While the chimes ring out with a carol gay,
For the joy that the day has brought,
Do you think what the end of a perfect day
Can mean to a tired heart,
When the sun goes down with a flaming ray,
And the dear friends have to part?

Carrie Jacobs Bond

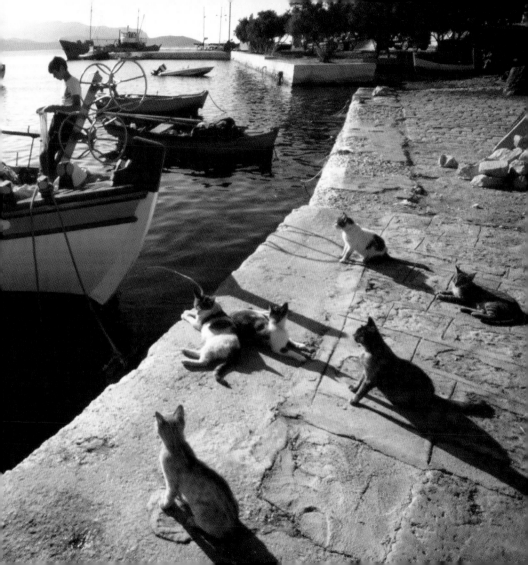

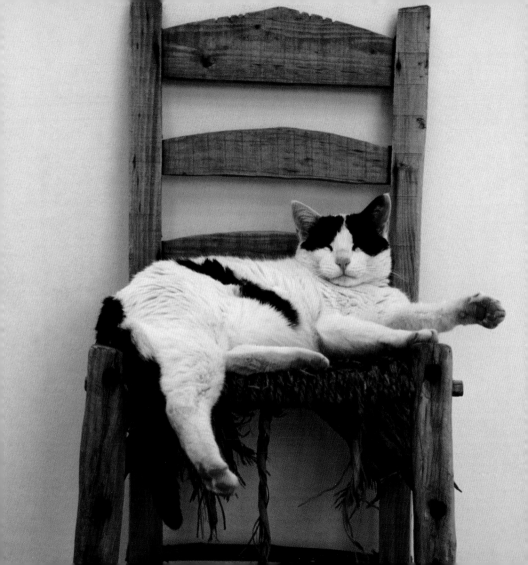

To know balance is to love peace.

Anne Wilson Schaef

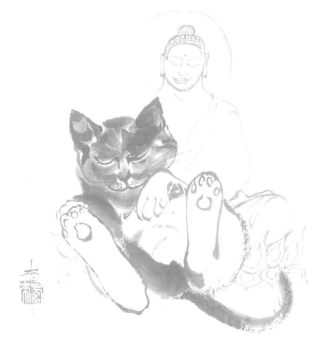

Acknowledgments

p.5 Excerpt from *Meditations for Living in Balance: Daily Solutions for People Who Do Too Much* by Anne Wilson Schaef. Copyright © 2000 by Anne Wilson Schaef. p.6 "Plans" by Evelyn Lang first published in *Hummingbird* ed. Phyllis Walsh Vol. IX, No. 1, September 1998. Copyright © 1998 by Evelyn Lang. p.9 "I sleep" by Kaga no Chiyo, translated by Curtis Hidden Page from his *Japanese Poetry* (Boston: Houghton Mifflin, 1923). p.19 "the waves" by Santoka translated by Cid Corman from the book *One Man's Moon*. Copyright © 1984 by Cid Corman. Reprinted by permission of Gnomon Press. p.23 "Mad Song" by Hester Sigerson. p.32 Excerpt from *Flight of White Crows: Stories, Tales and Paradoxes* by John Berry (MacMillan, 1961). p.39 "Letting" by Natsume Soseki, from *Zen Haiku* translated by Soiku Shigematsu. Used by permission of Weatherhill Inc. p.61 "I've left" by Natsume Soseki, from *Zen Haiku* translated by Soiku Shigematsu. Used by permission of Weatherhill Inc. p.62 Excerpt from *Waiting for Godot* by Samuel Beckett. Copyright © Samuel Beckett. Used by permission of Faber & Faber Ltd. p.66 Helen Keller. Courtesy of the American Foundation for the Blind, Helen Keller Archives. p.79 "Pebbles" by Natsume Soseki, from *Zen Haiku* translated by Soiku Shigematsu. Used by permission of Weatherhill Inc. p.81 Excerpt from "Stone Steps" by Chase Twichell from her *The Snow Watcher* (Bloodaxe Books, 1999). Copyright © 1998, 1999 by Chase Twichell. Used by permission of the publisher. p.85 Excerpt from "Laughing Corn" by Carl Sandburg from his *The Cornhuskers* (New York: Henry Holt and Co., 1918). p.93 Excerpt from *Meditations for Living in Balance: Daily Solutions for People who Do Too Much* by Anne Wilson Schaef. Copyright © 2000 by Anne Wilson Schaef.

Photo Credits

All inquiries should be addressed to:
Barron's Educational Series, Inc.
250 Wireless Boulevard
Hauppauge, New York 11788
http://www.barronseduc.com

International Standard Book No. 0-7641-5638-1

Library of Congress Catalog Card No. 2002110034

Series Editor: Leanne Bryan
Design: Balley Design Associates
Illustrations: André Sollier

Printed in China
9 8 7 6 5 4 3 2